HERE KITTY KITTY

mallory mcinnis

CHRONICLE BOOKS
SAN FRANCISCO

Library of Congress Cataloging-in-Publication Data:

Here kitty kitty.
 pages cm
 ISBN 978-1-4521-4244-9
1. Cats—Quotations, maxims, etc. I. McInnis, Mallory.

 PN6084.C23H47 2015
 818'.602--dc23

 2014043714

Manufactured in China

MIX
Paper from
responsible sources
FSC™ C008047
FSC
www.fsc.org

Design by Amanda Sim
Typeset in Ostrich Sans created by Tyler Finck

10 9 8 7 6 5 4 3 2 1

Chronicle Books LLC
680 Second Street
San Francisco, CA 94107
www.chroniclebooks.com

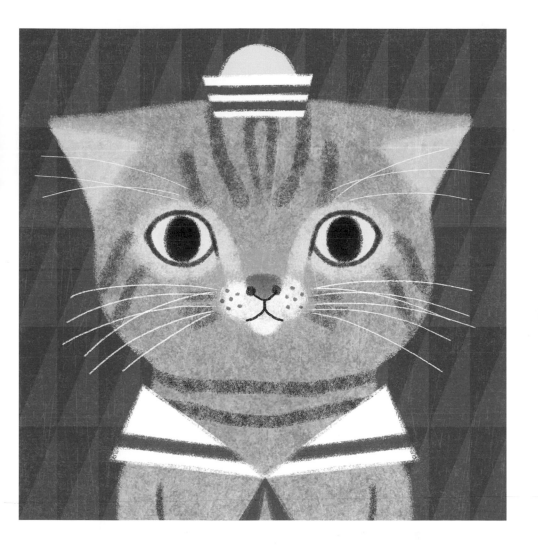

A LAP WITHOUT A CAT IS

a lonely one. Those charming whiskered creatures can wriggle their way into your heart just as easily as they manage to squeeze into any spare cardboard box or cupboard. Oh how we adore those balls of fur—even as that fur slowly covers every item of clothing, piece of furniture, and spare surface in the household. That's okay! The couch is pretty much just a scratch-post now anyway, so what's a bit of hair? Once you share your home with a cat, it becomes impossible to imagine a day without one. Lounging in your laundry, taking control of your pillows, leaving gory "gifts" at your front door, typing nonsense messages on your keyboard—life would be so much duller without their eccentricities adding color to your day.

Sure, cats can be tyrants. Yes, you may have a few scratches, and it's true that hungry morning meowing may wake you up with more frequency than your alarm clock, but those are small prices to pay for the joy we get in return. Just picture the intense, overwhelming cuteness of a cat sitting in a loaf-like position—perfection. Think of your pawed pet sweetly nuzzling you when you walk in the door at the end of the day—heavenly. Envision a basket full of fluffy kittens gazing at you sweetly, just begging to be cuddled—sublime.

What kind of cat has captured your heart? Is he Siamese or Scottish Fold? Siberian or Sphynx? Do you cuddle with a pint-sized Munchkin or a massive Maine Coon? Whether she's calico or tiger, shorthair or long—if you're holding this feline-celebrating book in your hands, you must be a cat lover.

When your favorite friend is a feline, your phone is bound to be overflowing with cat photos, and your Instagram account littered with kitten snapshots. So let's take a break and gaze at some cats created in ink, paint, or pixels for a change. *Here Kitty Kitty* is like catnip for kitty caretakers. Each charming illustration in the volume will make a cat lady (or gent) purr like a kitten that has found the perfect sunny spot to bask in. With each turn of the page, you'll find artwork by an illustrator who can capture the eloquence of a tail twitch or appreciates the feeling of getting your legs licked after you get out of the shower.

These quirky and charming illustrations both capture the delightful (yet some-times peculiar) realities of cat ownership (the bed hogging, the aloofness, the yarn predilection) and also showcase our furry friends in more fantastical ways (cupcake cats, cats riding bikes, kitties frolicking with tigers, cats wearing pajamas). Alongside these delightful depictions, we've sprinkled an array of quotations from a selection of cat-loving famous folks. The words beautifully articulate what the artists convey in images: a deep appreciation for the mysterious, meowing, yowling cats we cherish so deeply.

So grab the constantly snoozing object of your affection and cuddle up on that hair-covered couch. Give your beloved pet a bit of a chin-scratch and turn your attention to this heart-warming collection of quirky, witty, cranky, lovable kitties.

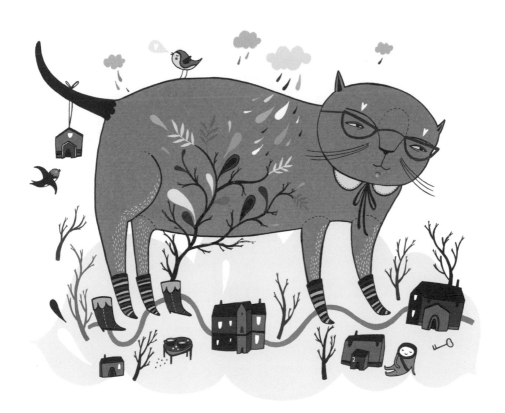

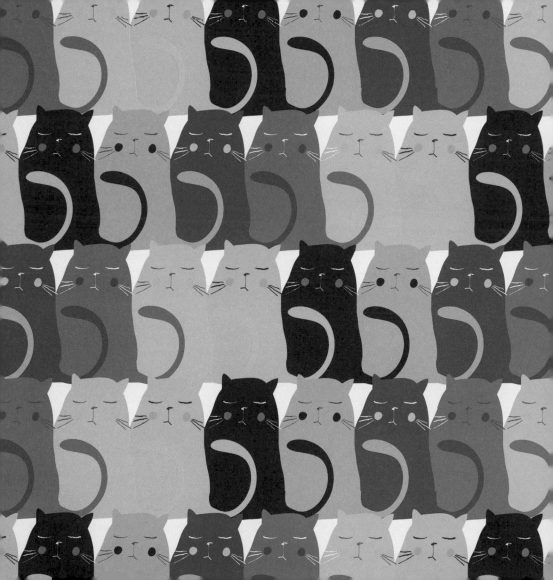

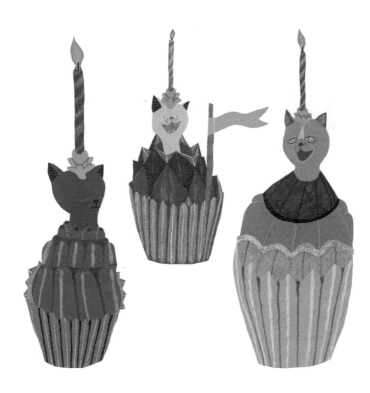

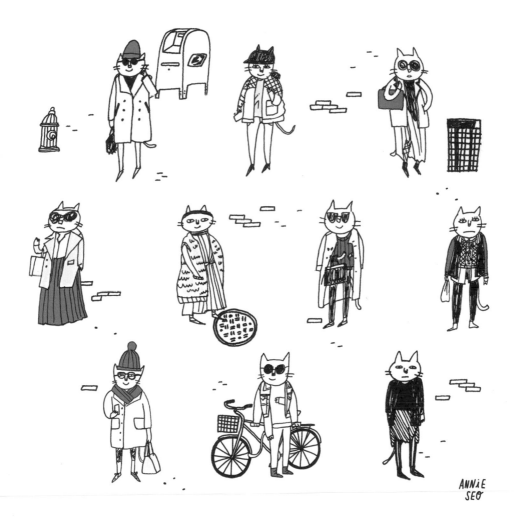

ANNiE
SEO

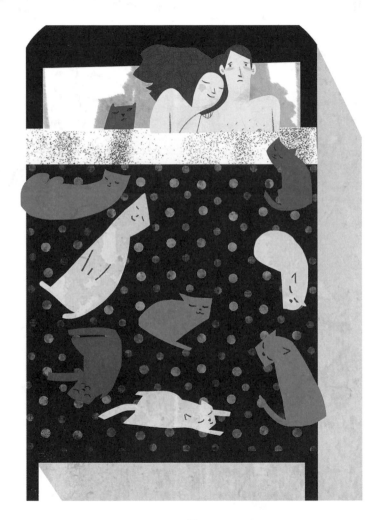

I WRITE SO MUCH BECAUSE MY CAT SITS ON MY LAP. SHE PURRS SO I DON'T WANT TO GET UP. SHE'S SO MUCH MORE CALMING THAN MY HUSBAND.

JOYCE CAROL OATES

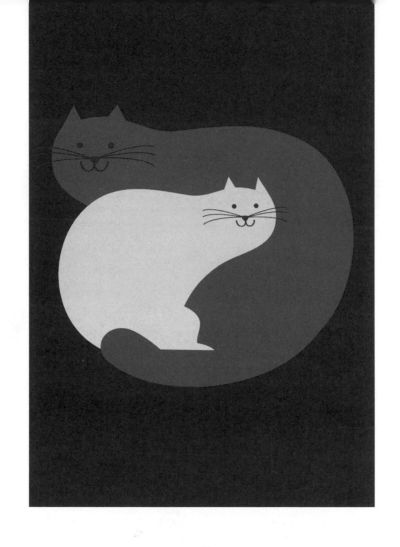

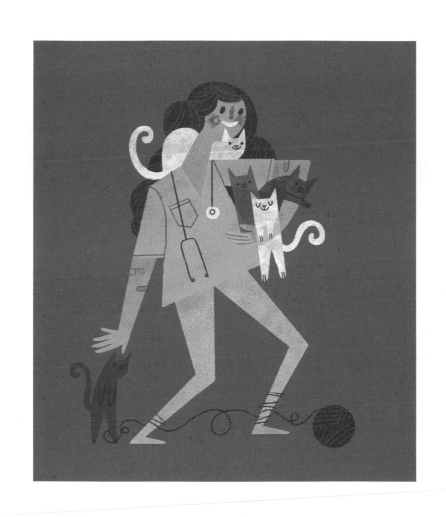

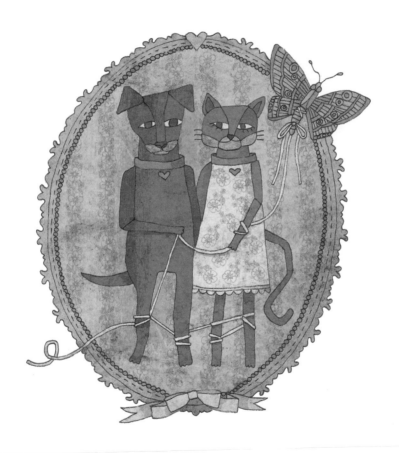

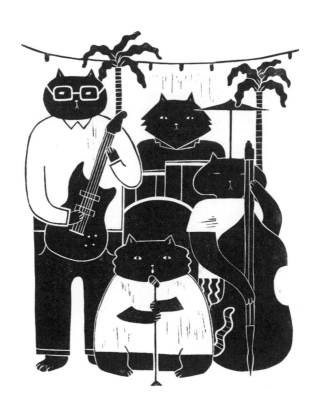

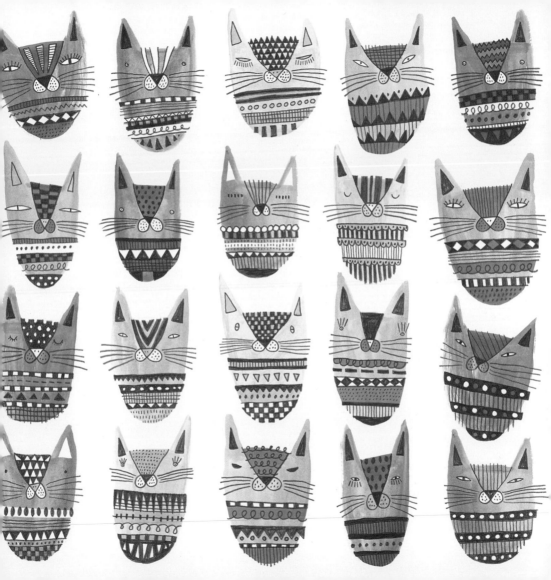

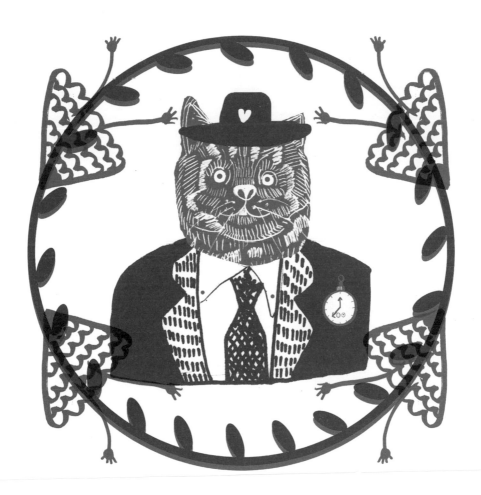

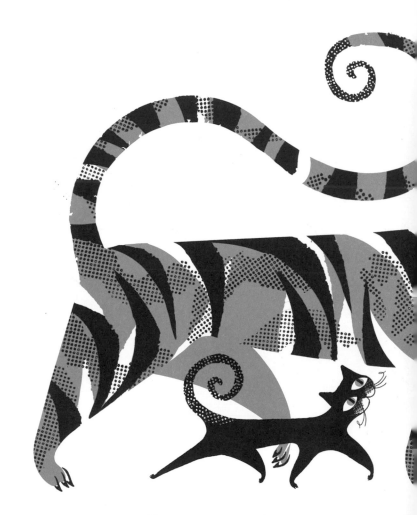

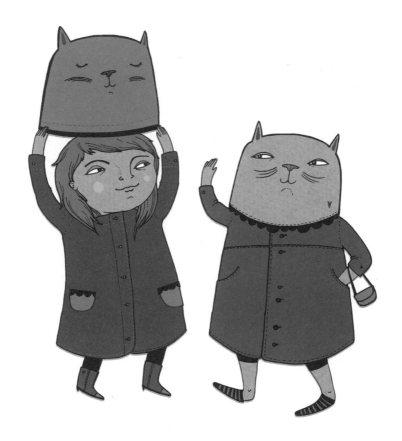

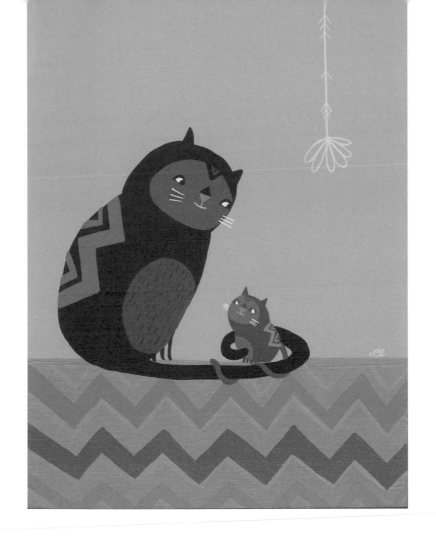

CATS CAN BE VERY FUNNY, AND HAVE THE ODDEST WAYS OF SHOWING THEY'RE GLAD TO SEE YOU. RUDIMACE ALWAYS PEED IN OUR SHOES.

W. H. AUDEN

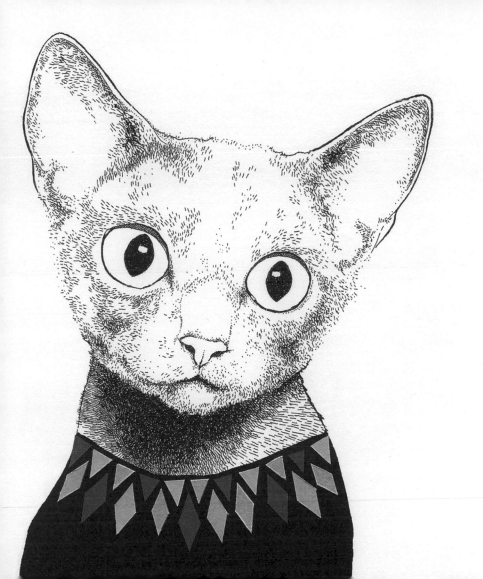

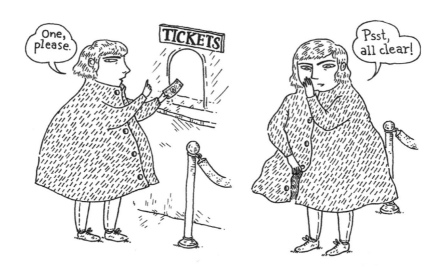

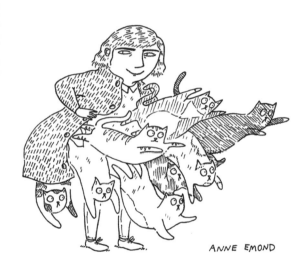

ANNE EMOND

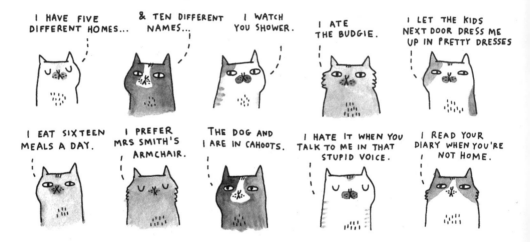

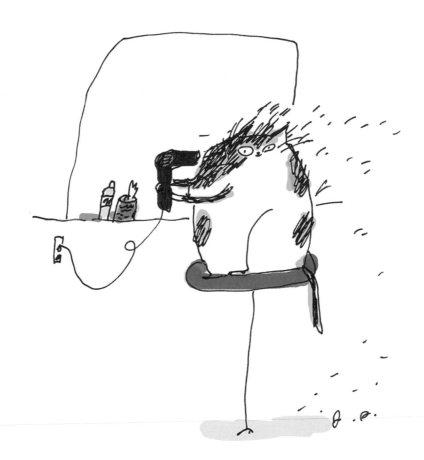

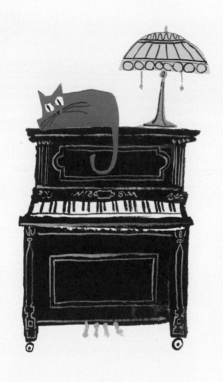

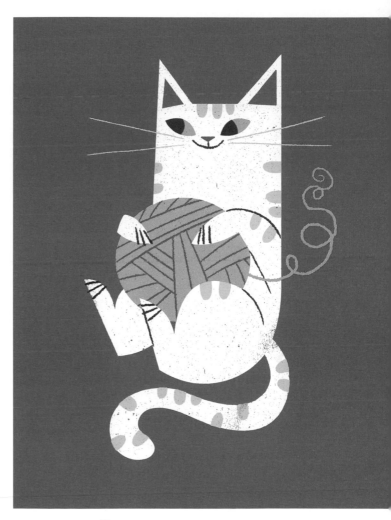

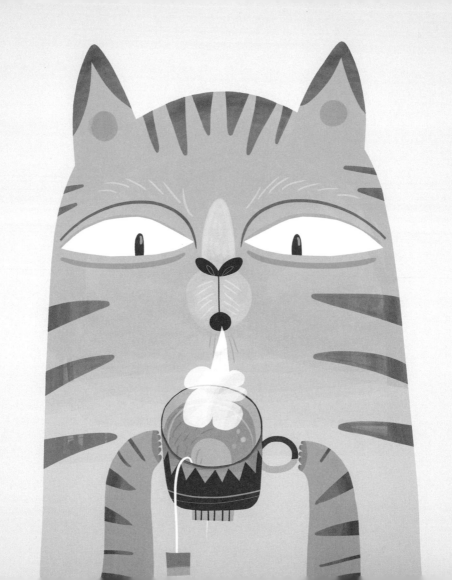

CATS ARE
CONNOISSEURS
OF COMFORT.

JAMES HERRIOT

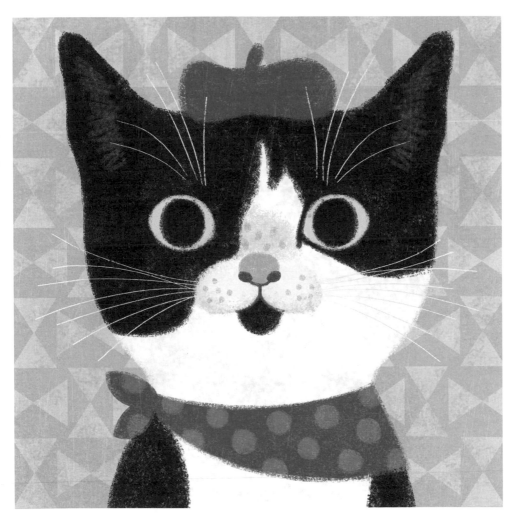

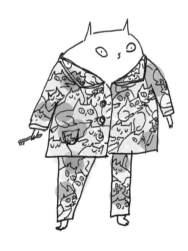

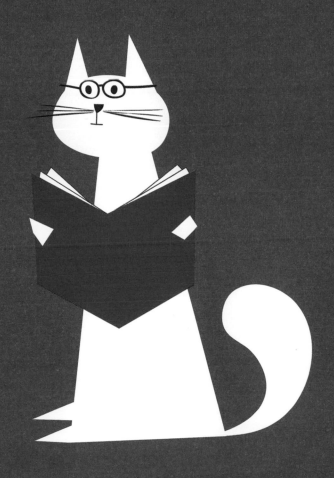

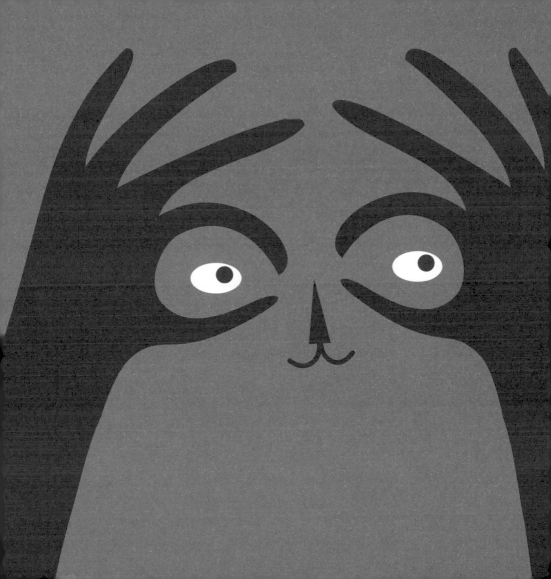

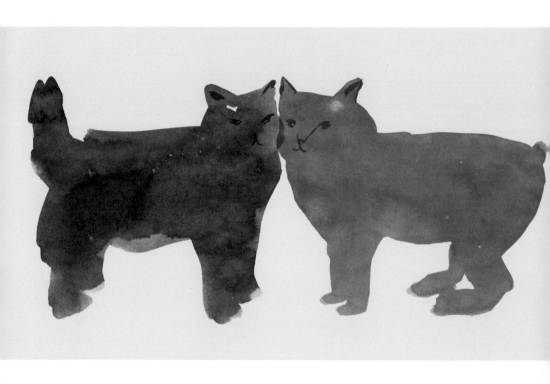

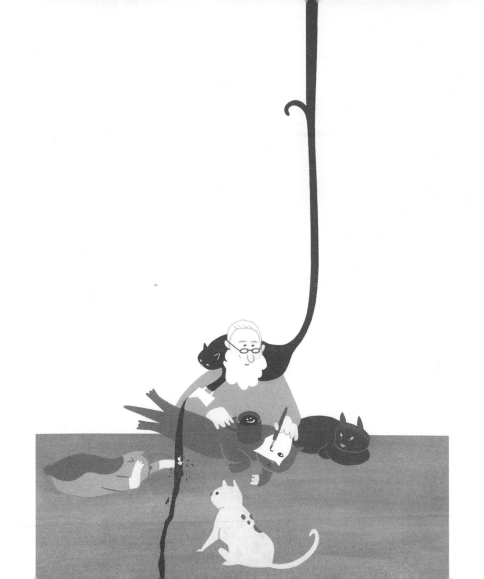

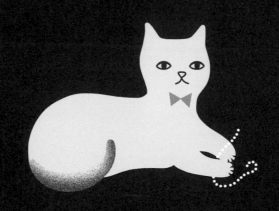

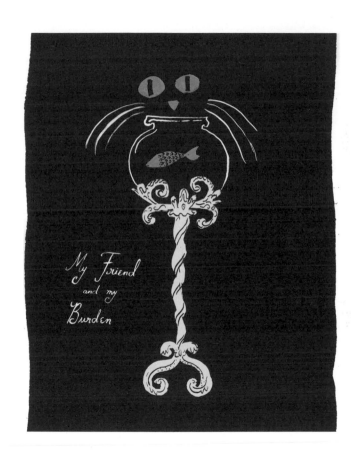

My Friend
and my
Burden

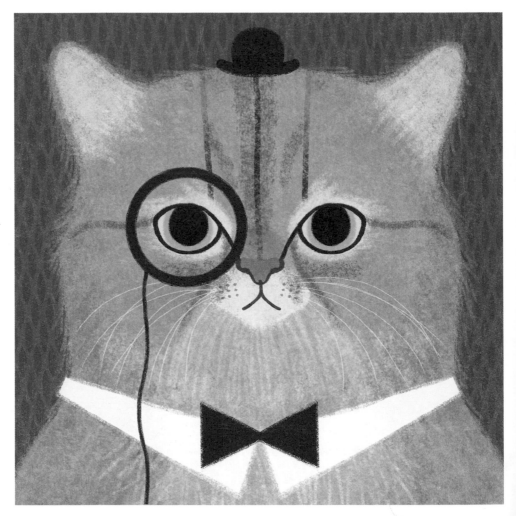

A CAT IS MORE INTELLIGENT
THAN PEOPLE BELIEVE, AND
CAN BE TAUGHT ANY CRIME.

MARK TWAIN

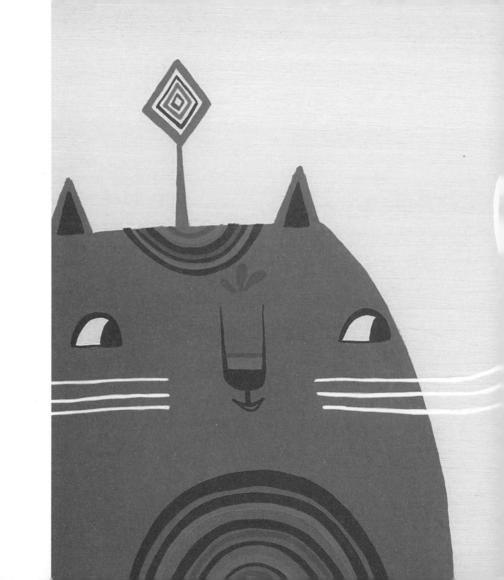

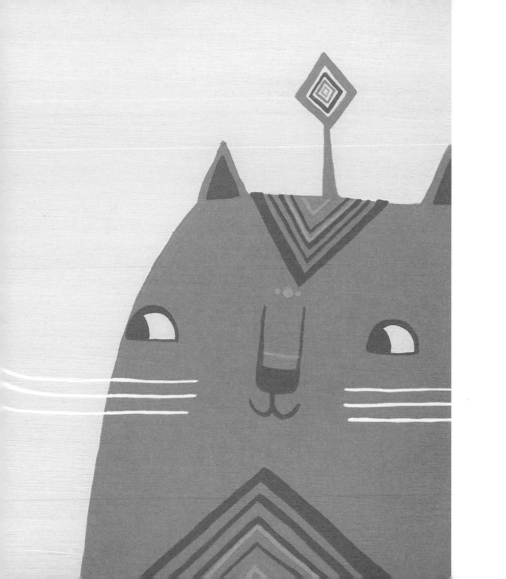

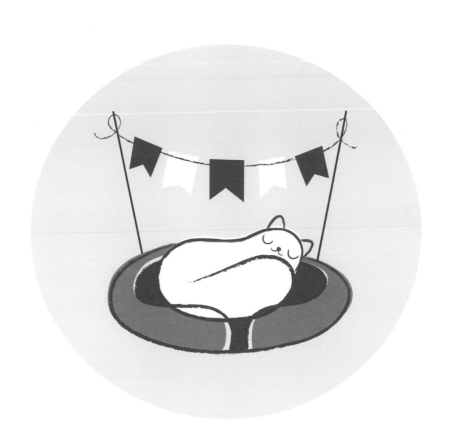

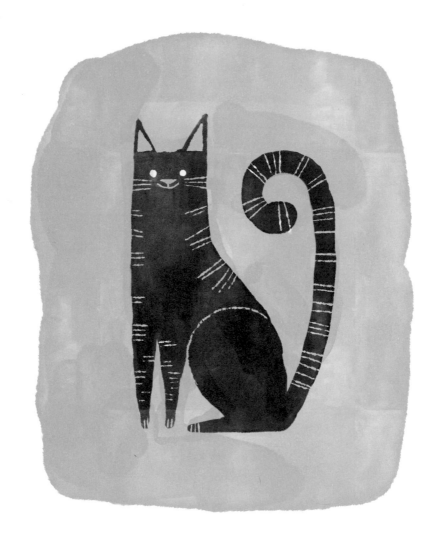

THE TAIL, IN CATS, IS
THE PRINCIPAL ORGAN OF
EMOTIONAL EXPRESSION.

ALDOUS HUXLEY

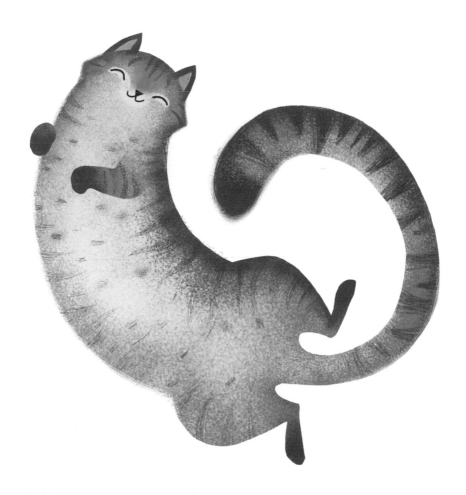

WHAT SORT OF PHILOSOPHERS
ARE WE, WHO KNOW
ABSOLUTELY NOTHING OF THE
ORIGIN AND DESTINY OF CATS?

HENRY DAVID THOREAU

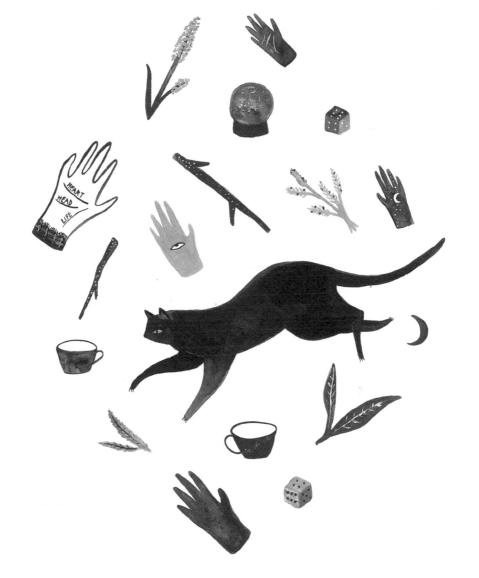

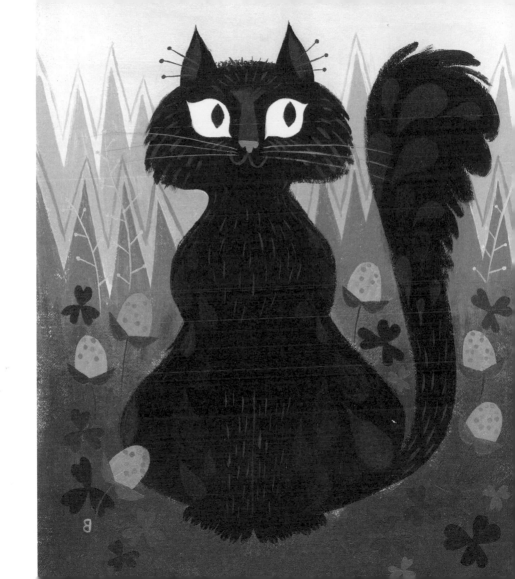

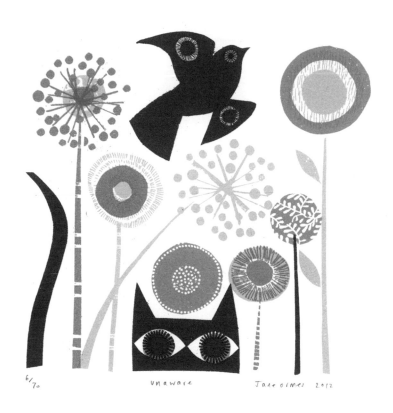

6/70 unaware Jane Ormes 2012

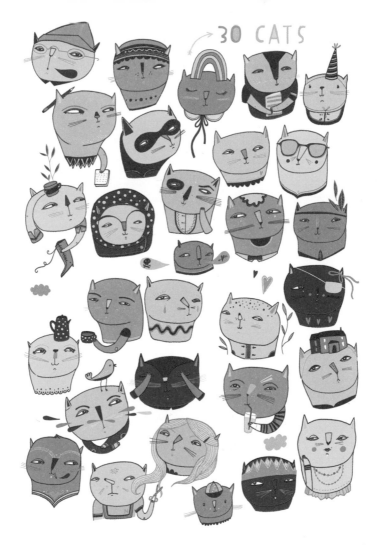

30 CATS

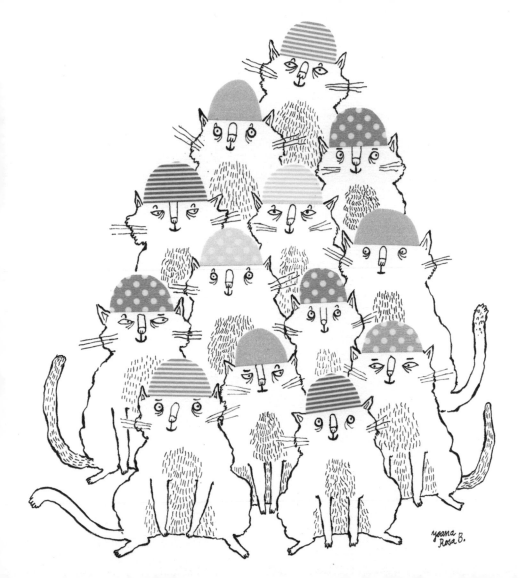

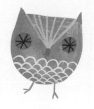
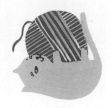

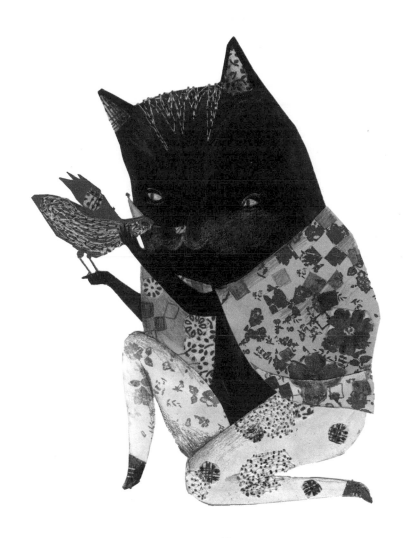

IT IS IN THE NATURE OF CATS TO DO A CERTAIN AMOUNT OF UNESCORTED ROAMING.

ADLAI E. STEVENSON

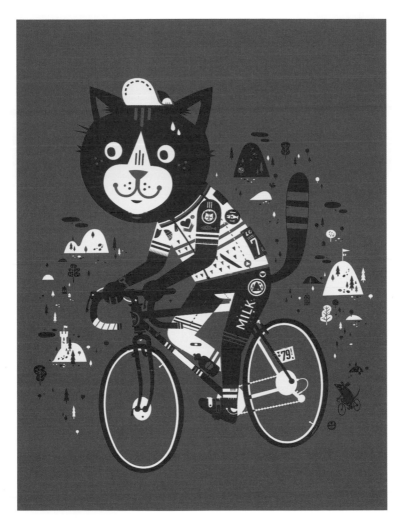

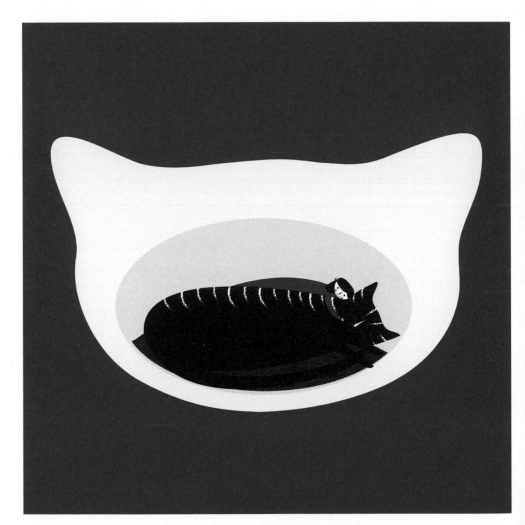

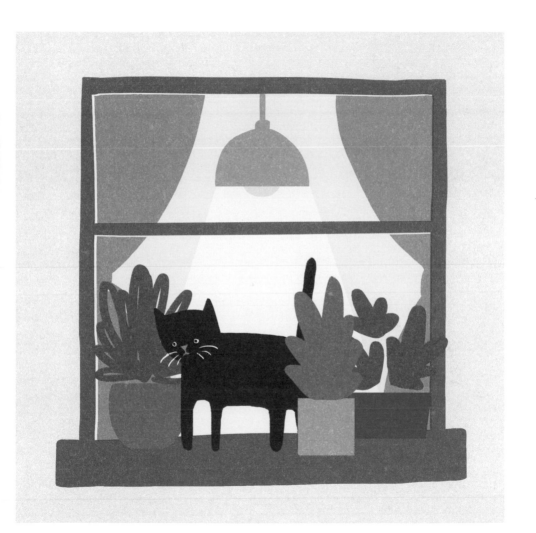

IF A FISH IS THE MOVEMENT
OF WATER EMBODIED,
GIVEN SHAPE, THEN CAT IS
A DIAGRAM AND PATTERN
OF SUBTLE AIR.

DORIS LESSING

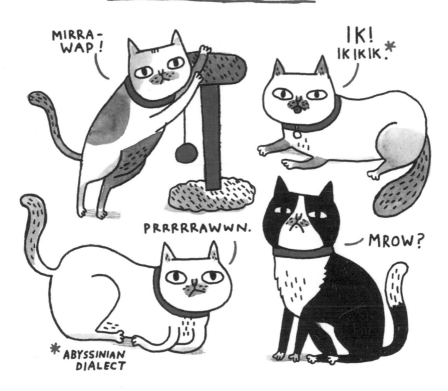

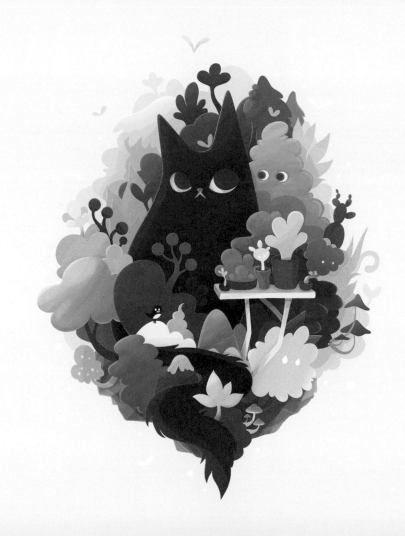

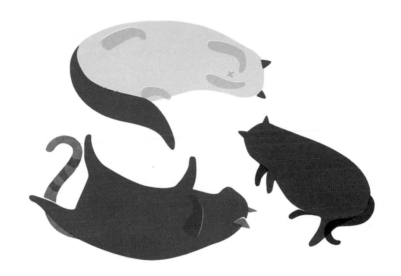

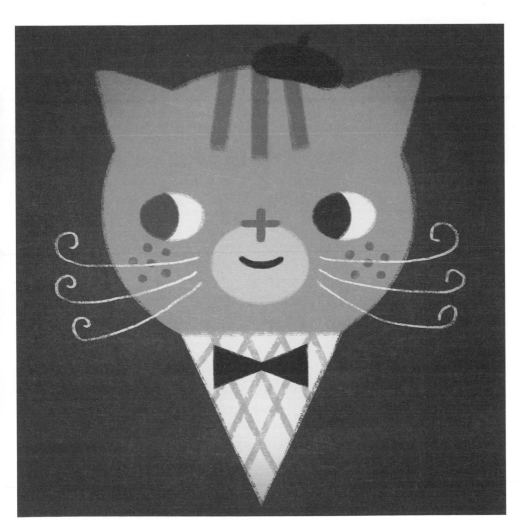

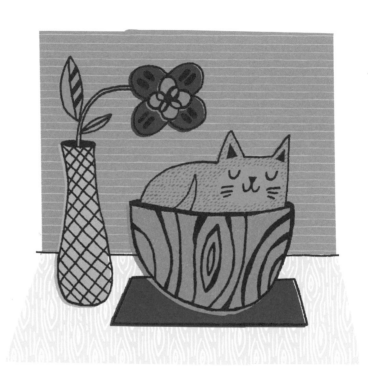

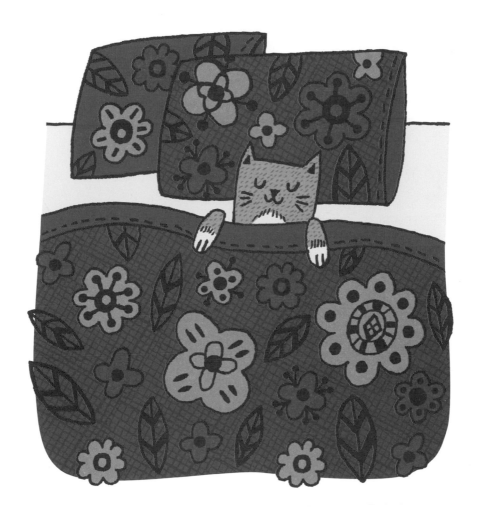

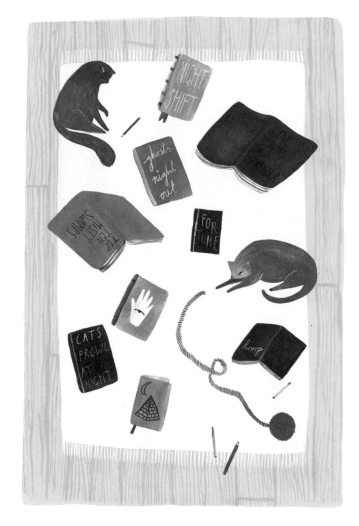

WHEN I PLAY WITH MY CAT,
HOW DO I KNOW THAT SHE IS
NOT PASSING TIME WITH ME
RATHER THAN I WITH HER?

MICHEL DE MONTAIGNE

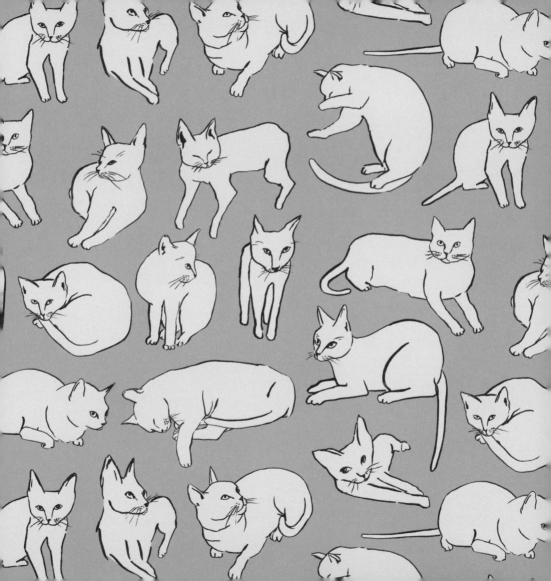

albert & marie

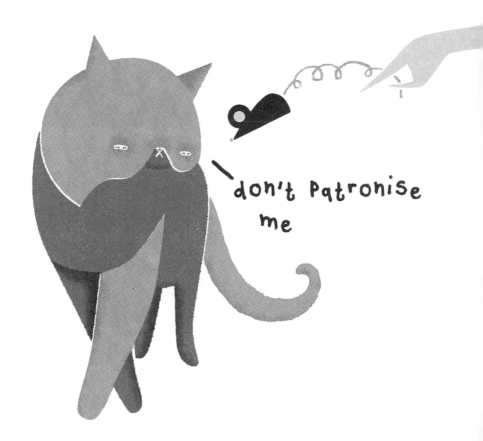

THE CAT IS ONLY
DOMESTIC AS
FAR AS IT SUITS
ITS OWN ENDS.

SAKI (H. H. MONROE)

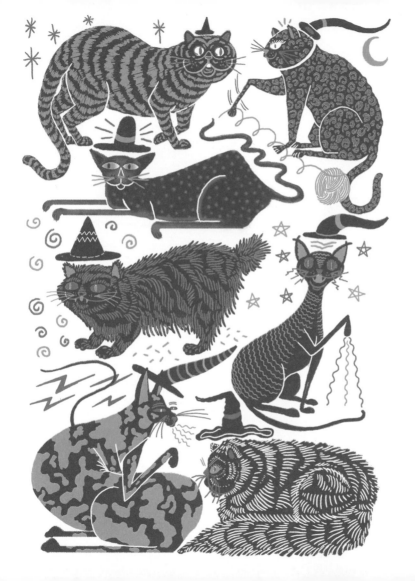

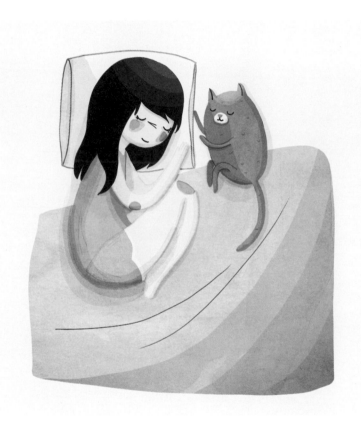

THE CAT DOES NOT OFFER SERVICES. THE CAT OFFERS ITSELF.

WILLIAM S. BURROUGHS

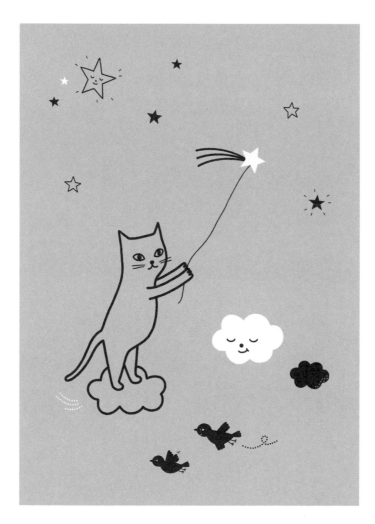

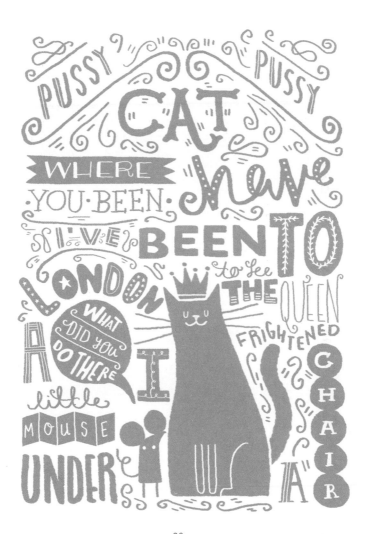

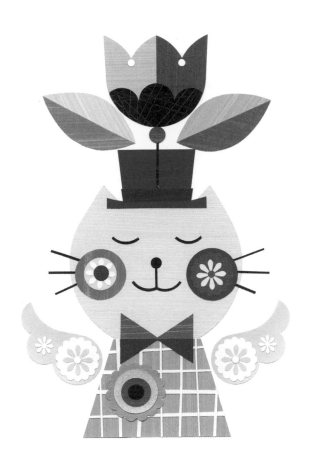

THE PROBLEM WITH CATS IS THAT THEY GET THE SAME EXACT LOOK WHETHER THEY SEE A MOTH OR AN AXE MURDERER.

PAULA POUNDSTONE

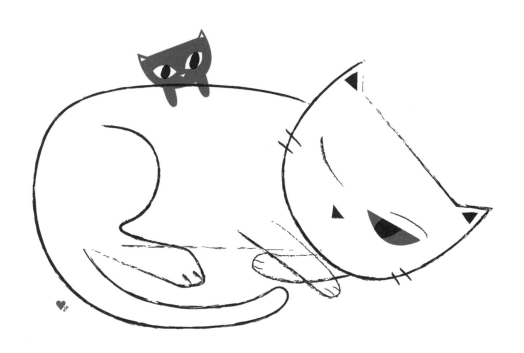

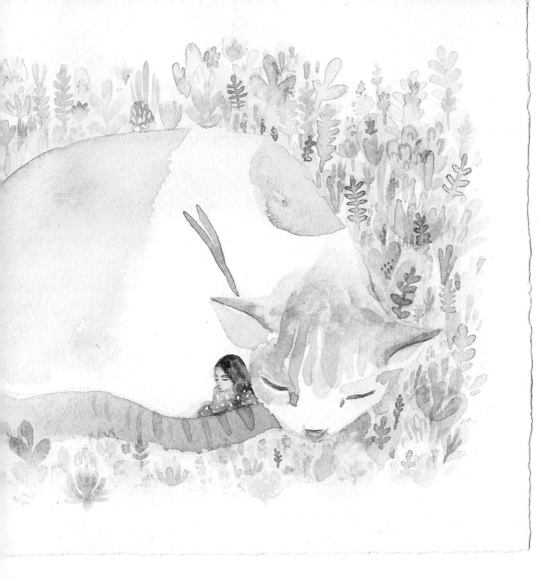

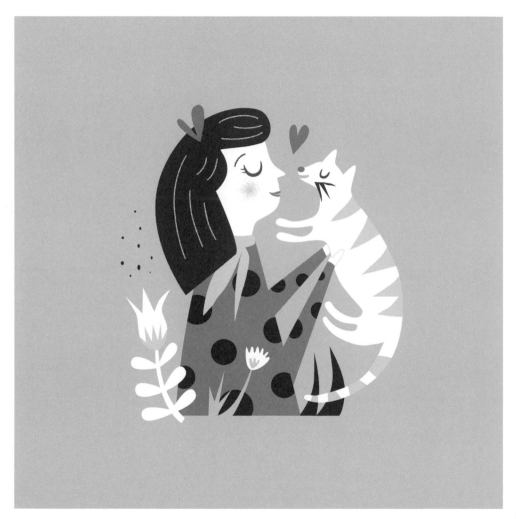

HOLDING UP MY
PURRING CAT TO THE
MOON, I SIGHED.

JACK KEROUAC

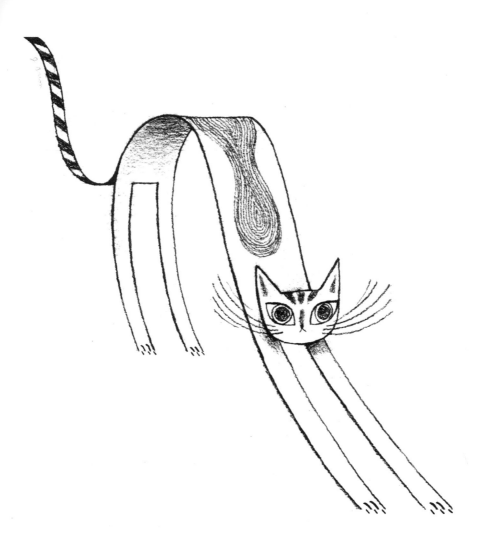

THOSE WHO'LL PLAY WITH CATS MUST EXPECT TO BE SCRATCHED.

MIGUEL DE CERVANTES

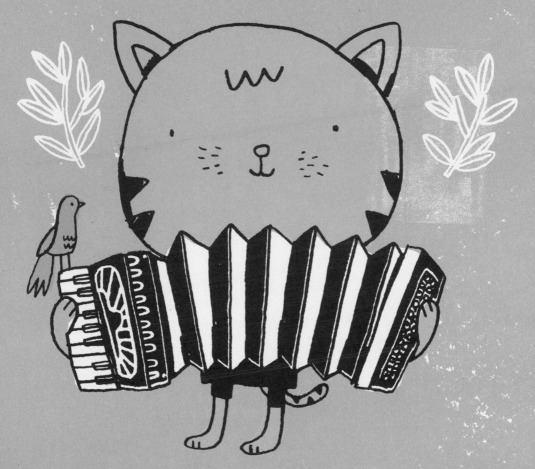

I REALLY LIKE YOU.

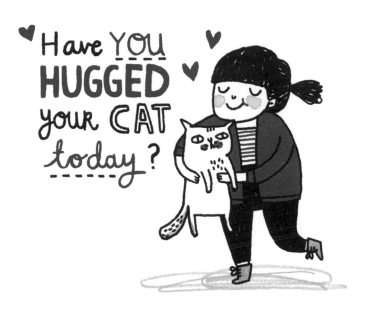

IMAGE CREDITS

All images copyright © by the individual artists.

QUOTATION CREDITS

page 13 COMMENT MADE IN JEST AT BOSTON BOOK FAIR. PERMISSION TO PRINT COURTESY OF JOYCE CAROL OATES.

page 26 EXCERPT FROM INTERVIEW WITH W.H. AUDEN BY *THE PARIS REVIEW*. COPYRIGHT © 1972 BY *THE PARIS REVIEW*, ORIGINALLY APPEARED IN ITS SPRING 1974 THE ART OF POETRY NO. 17 ISSUE, USED BY PERMISSION OF THE WYLIE AGENCY LLC.

page 35 FROM *JAMES HERRIOT'S CAT STORIES* BY JAMES HERRIOT. REPRINTED BY PERMISSION OF ST. MARTIN'S PRESS.

page 49 FROM *NOTEBOOK*, 1895 BY MARK TWAIN.

page 55 FROM *MUSIC AT NIGHT AND OTHER ESSAYS* BY ALDOUS HUXLEY. COPYRIGHT © 1931, RENEWED 1958 BY ALDOUS HUXLEY. REPRINTED BY PERMISSION OF GEORGES BORCHARDT, INC., FOR THE ESTATE OF ALDOUS HUXLEY.

page 58 FROM *THOREAU JOURNAL 9* BY HENRY DAVID THOREAU.

page 70 FROM ADLAI E. STEVENSON'S VETO OF ILLINOIS SENATE BILL NO. 93, "AN ACT TO PROVIDE PROTECTION TO INSECTIVOROUS BIRDS BY RESTRAINING CATS."

page 75 FROM *PARTICULARLY CATS* BY DORIS LESSING. PERMISSION TO REPRINT COURTESY OF JONATHAN CLOWES LIMITED.

page 85 FROM *AN APOLOGY FOR RAYMOND SEBOND* BY MICHEL DE MONTAIGNE.

page 91 FROM "THE ACHIEVEMENT OF THE CAT" BY SAKI (HECTOR HUGH MUNRO)

page 97 FROM *THE CAT INSIDE* BY WILLIAM S. BURROUGHS, COPYRIGHT © 1986, 1992 BY WILLIAM S. BURROUGHS. USED BY PERMISSION OF VIKING PENGUIN, A DIVISION OF PENGUIN GROUP (USA) LLC. USED ELECTRONICALLY BY PERMISSION OF THE WYLIE AGENCY LLC.

page 102 PERMISSION TO PRINT COURTESY OF PAULA POUNDSTONE.

page 107 THANKS TO THE KEROUAC ESTATE.

page 112 FROM *DON QUIXOTE DE LA MANCHA* BY MIGUEL DE CERVANTES.

MALLORY MCINNIS is a
writer from the woods of Maine
now living in New York City. She
spends a lot of time on the Internet
amassing things to share on her blog,
Gems (www.lookatthesegems.com).
She would like to own an Exotic
Shorthair cat one day.